Soothing Geometry

Rosalind Flower

Copyright © 2016 Rosalind Flower

Printed by CreateSapce,

An Amazon.com Company

All rights reserved.

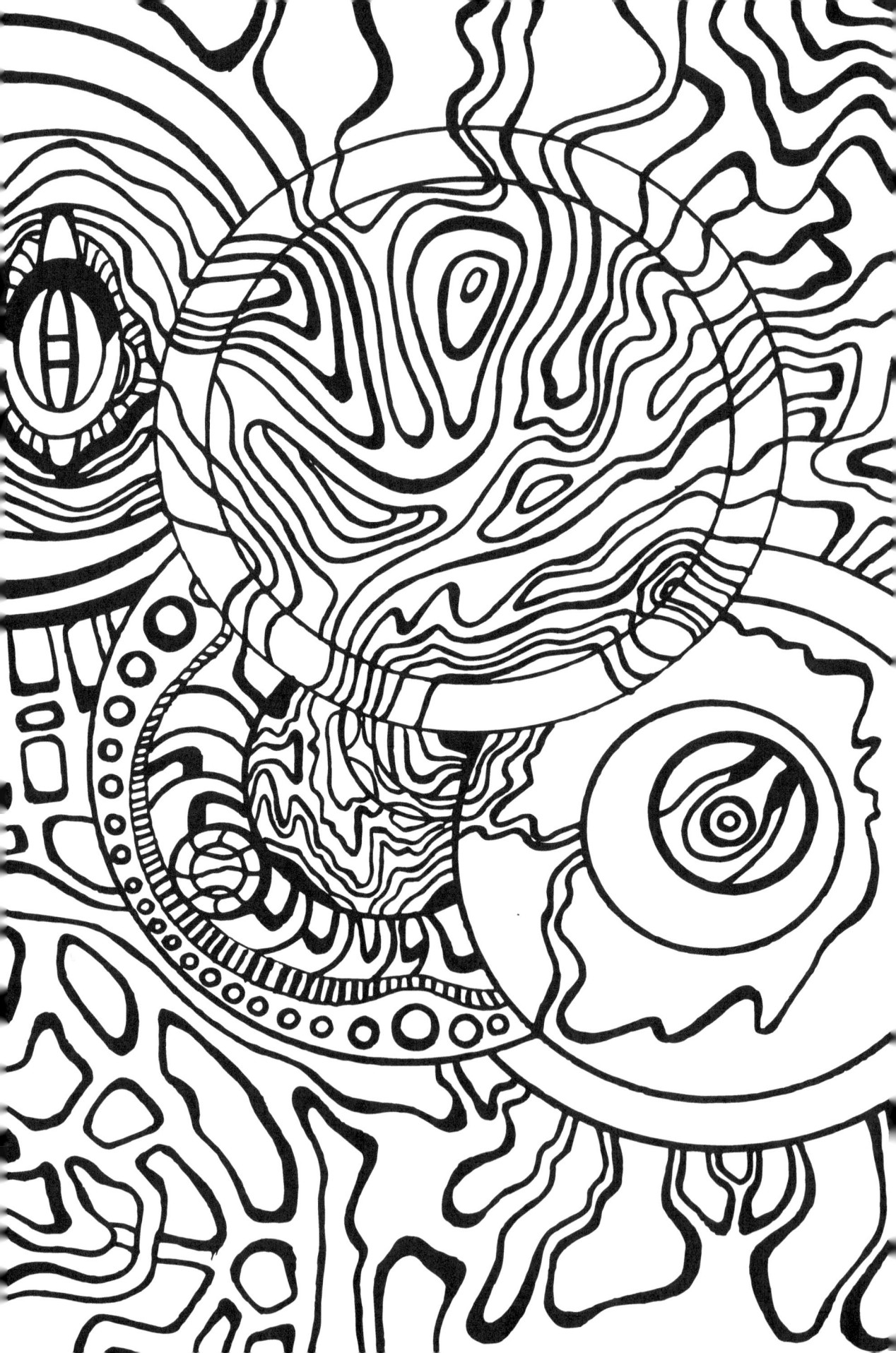

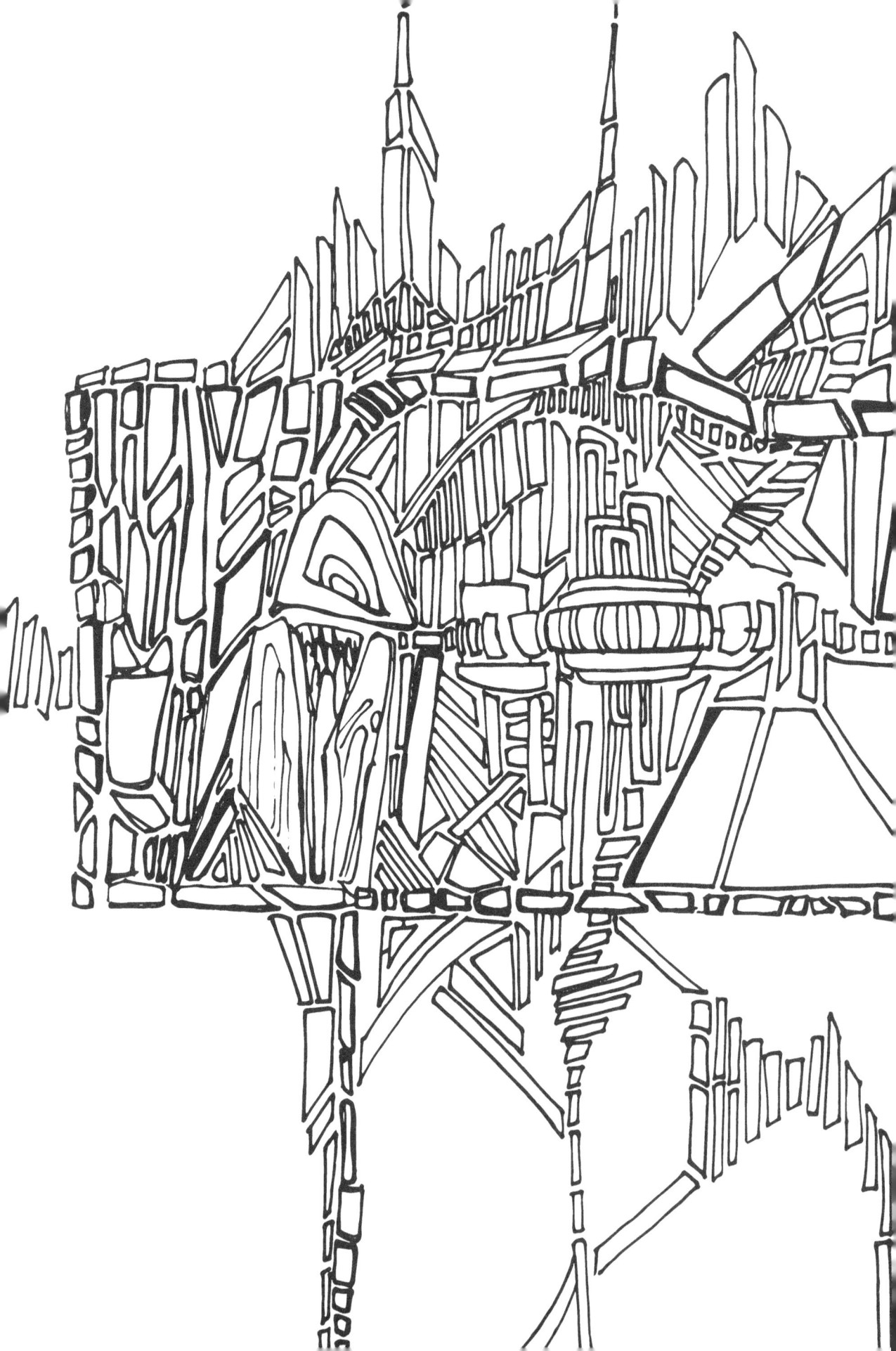

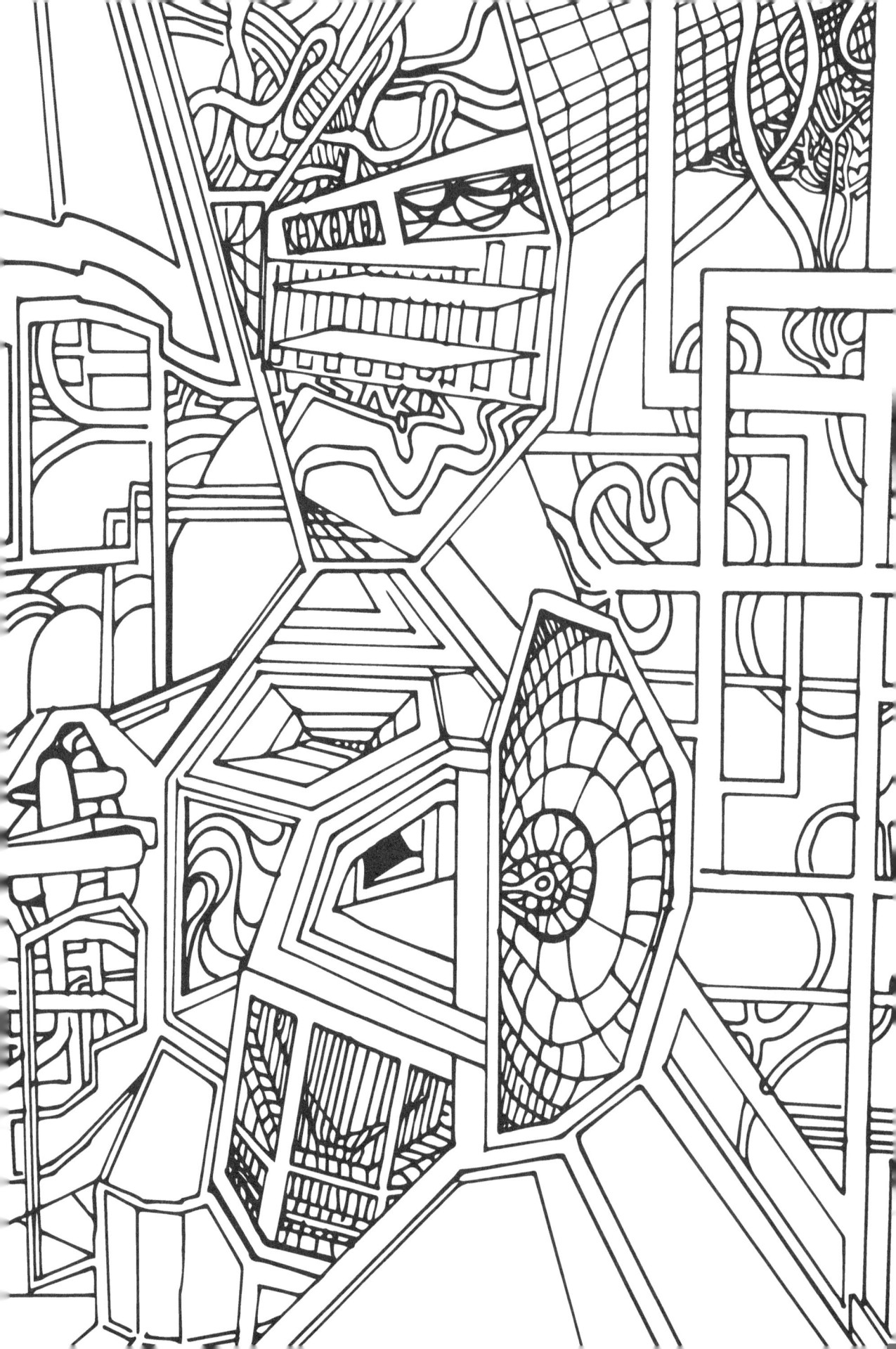

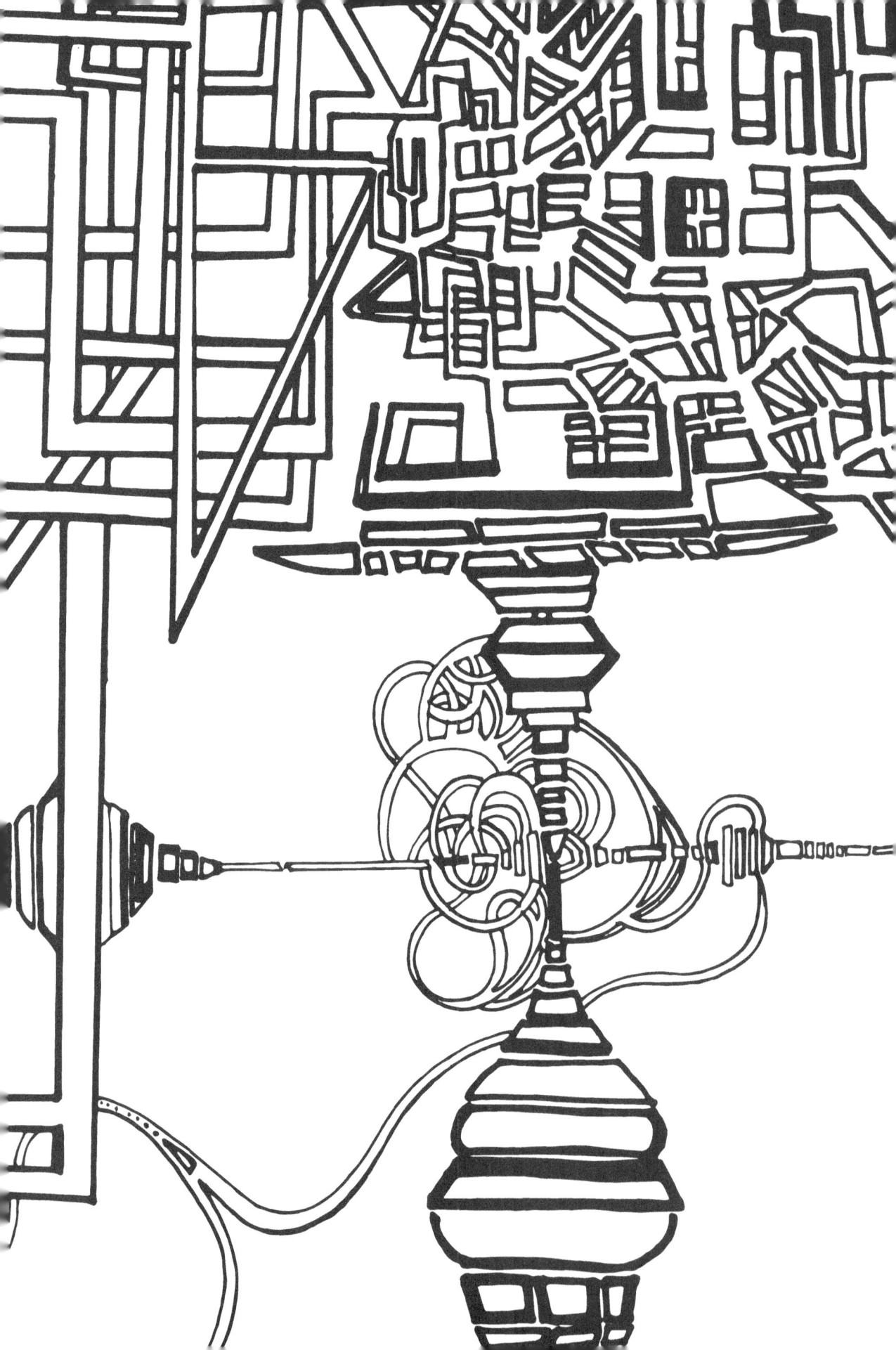

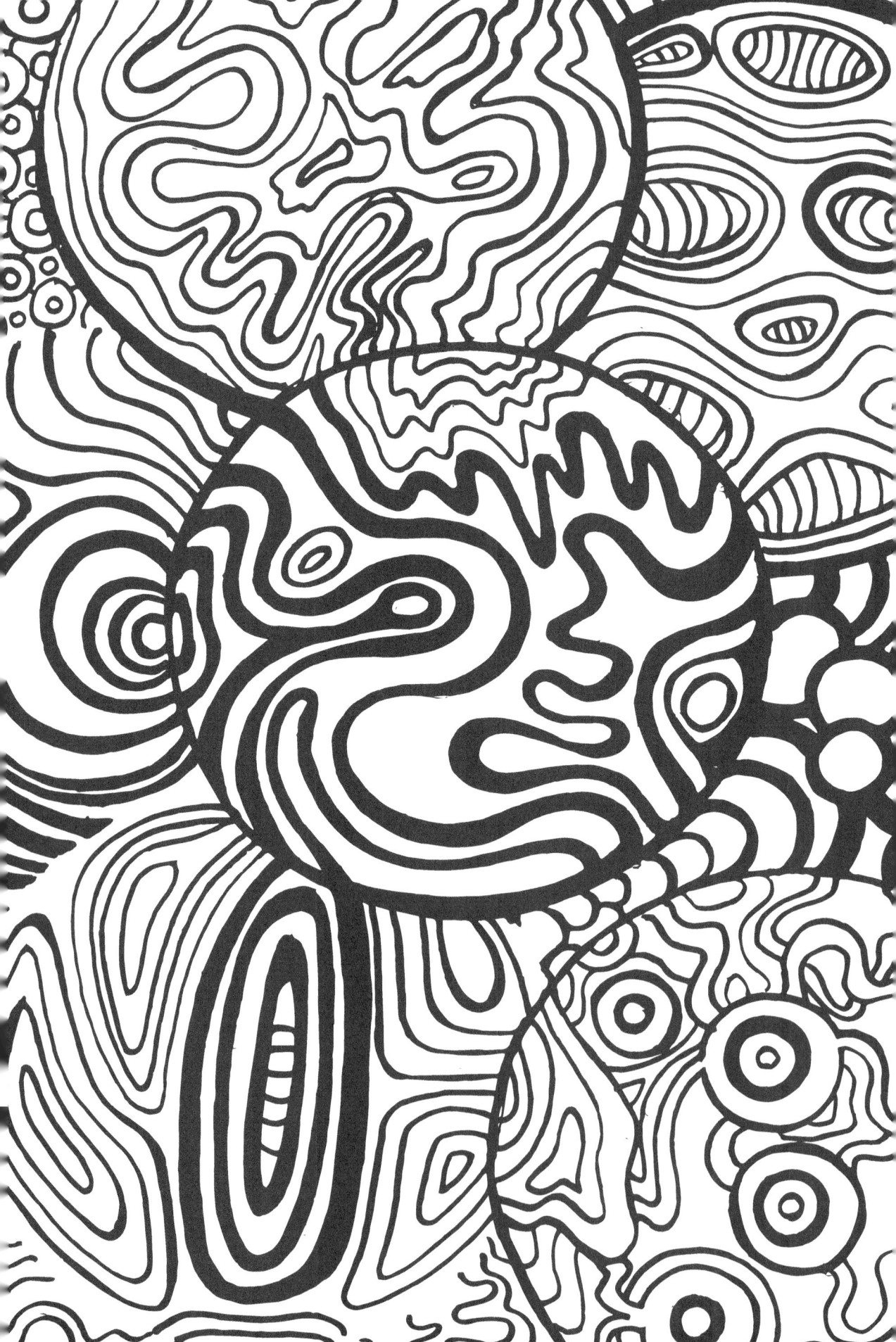

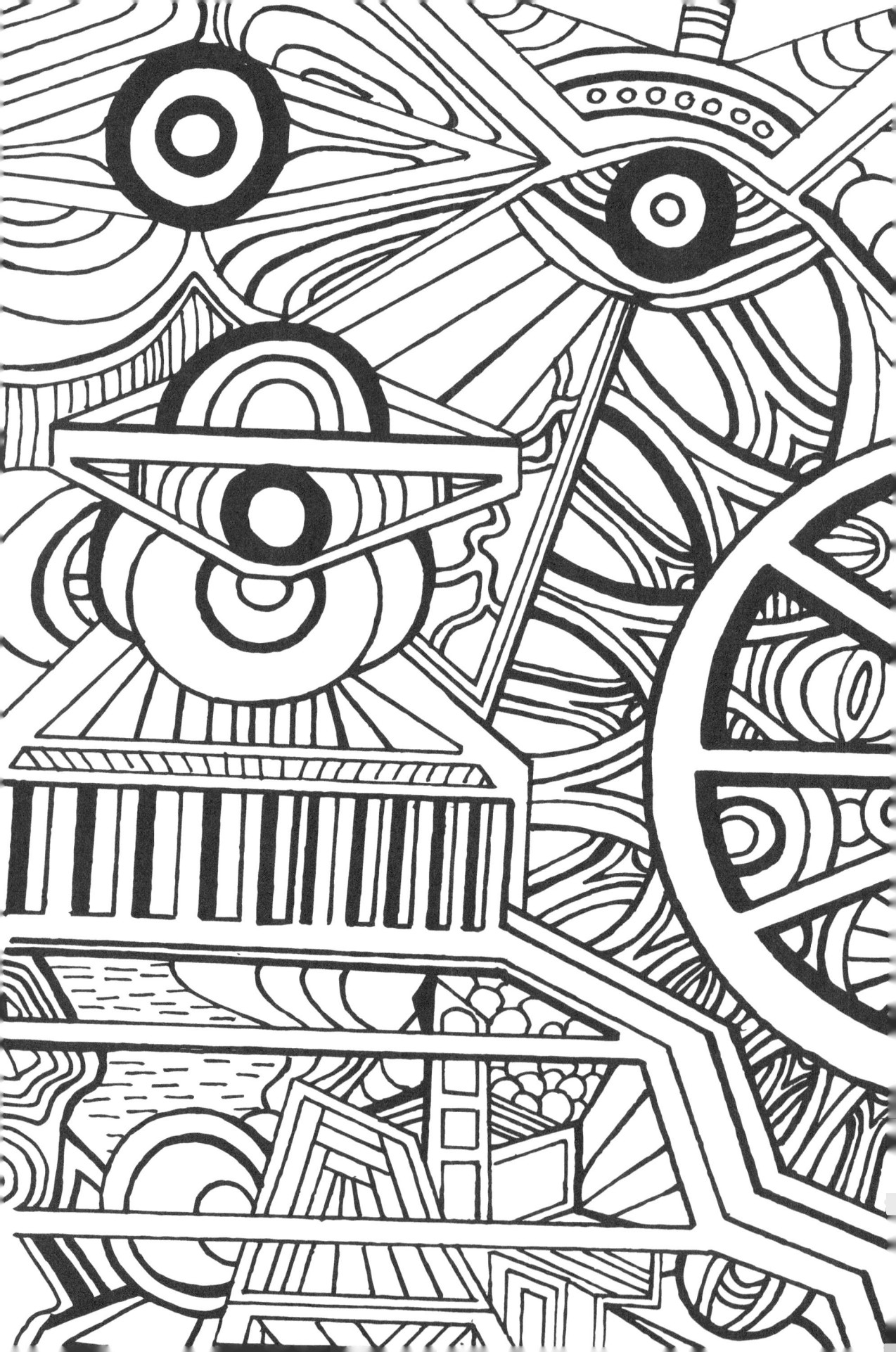

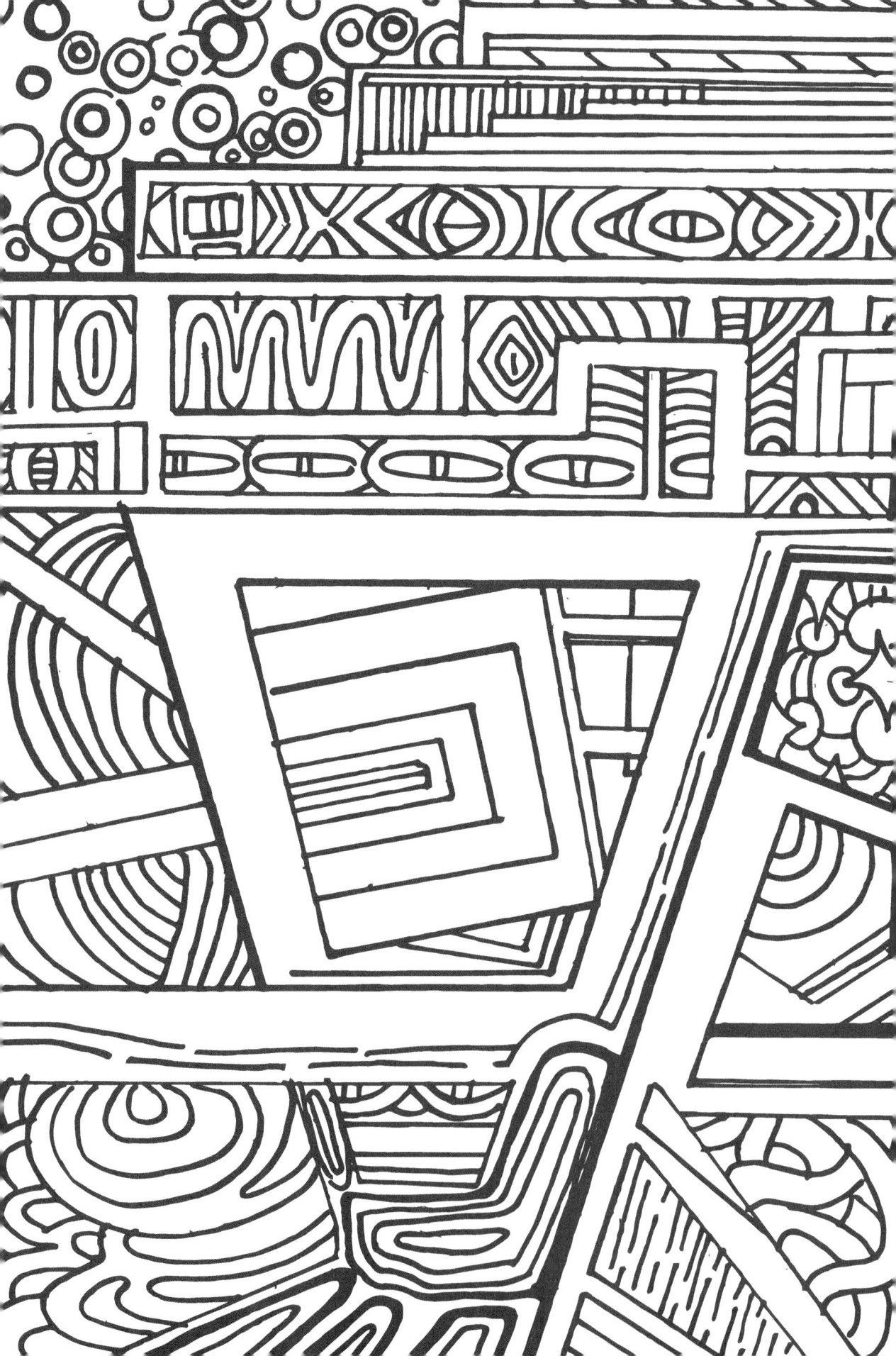

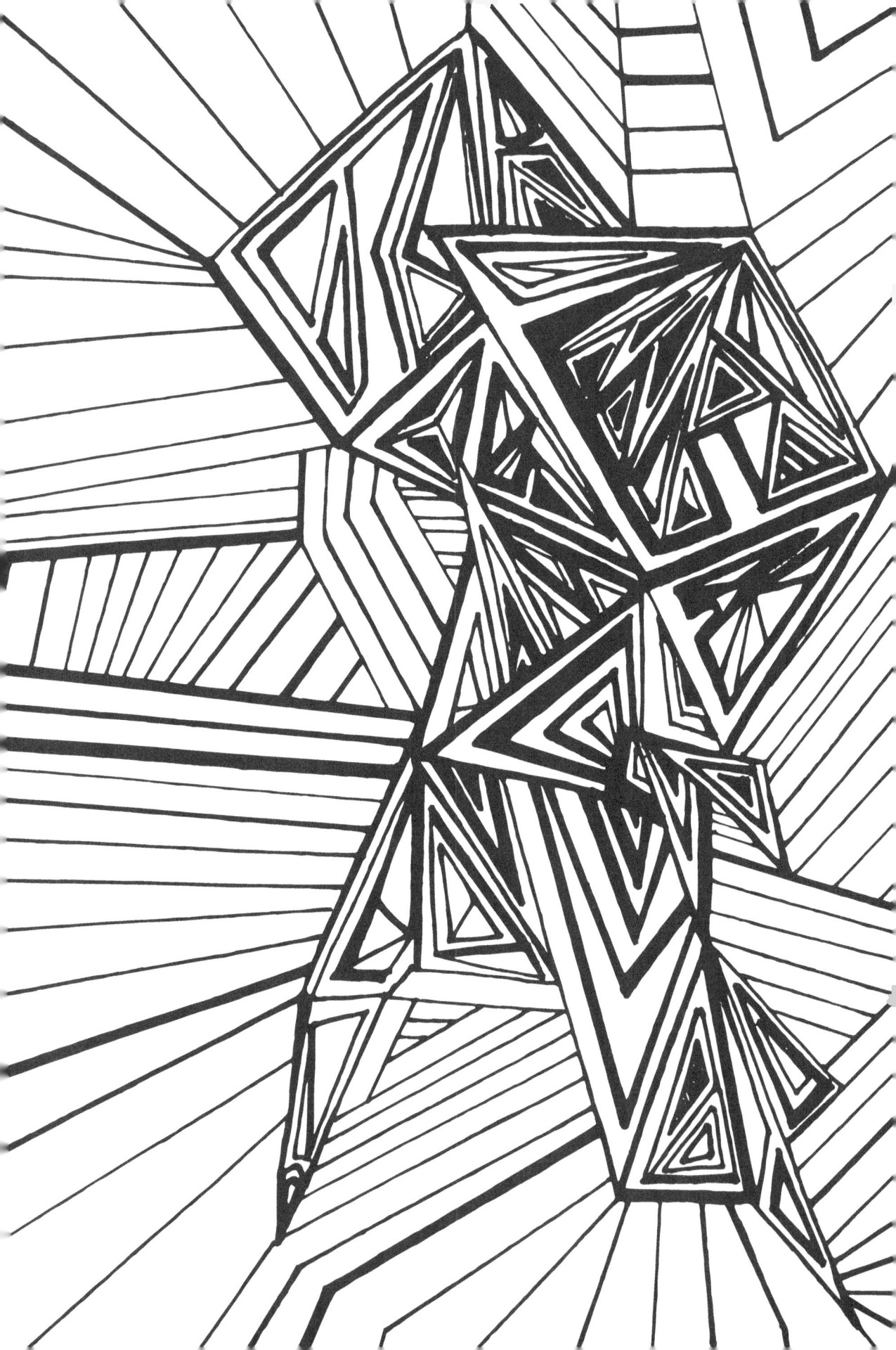

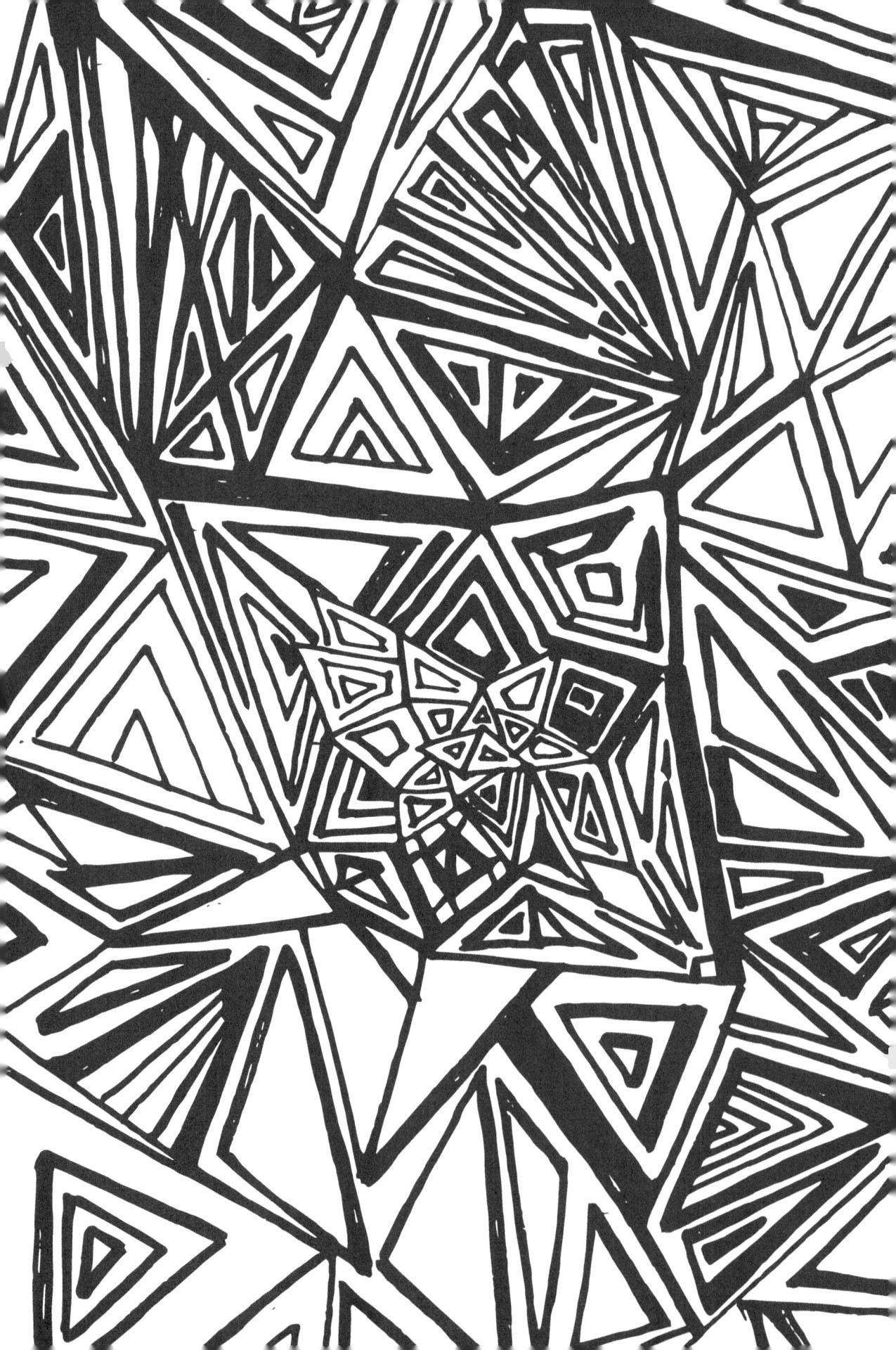

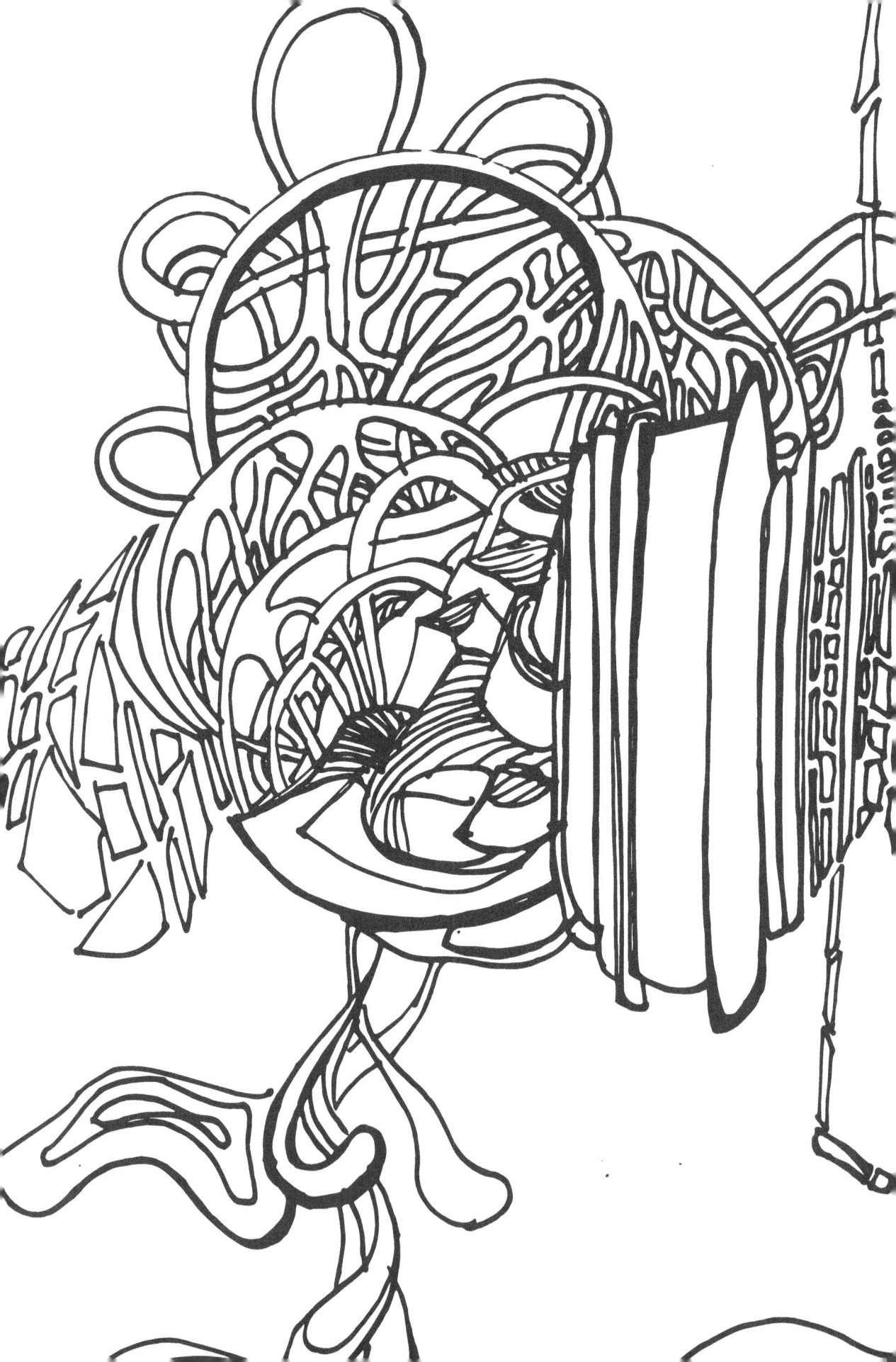

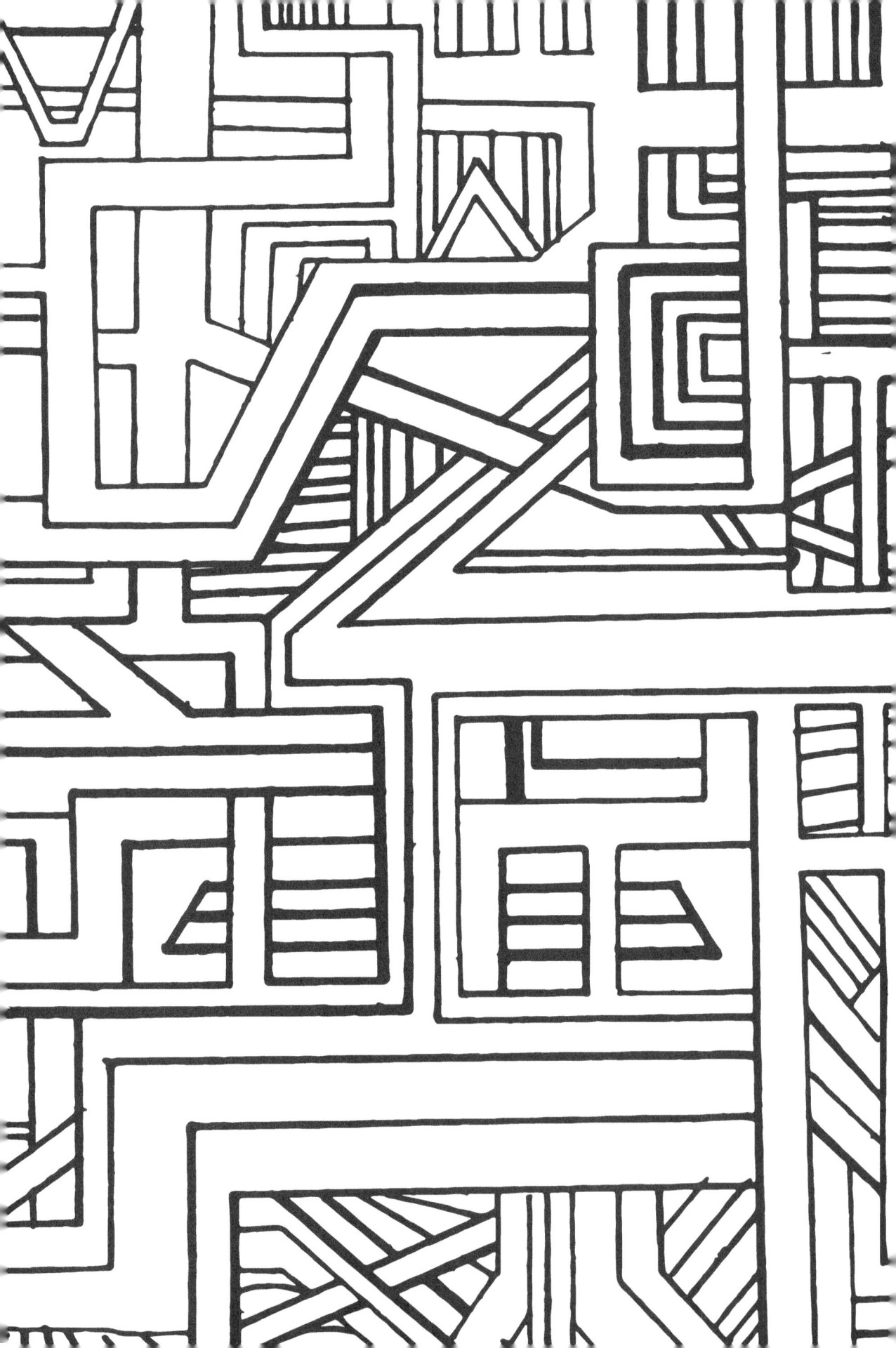

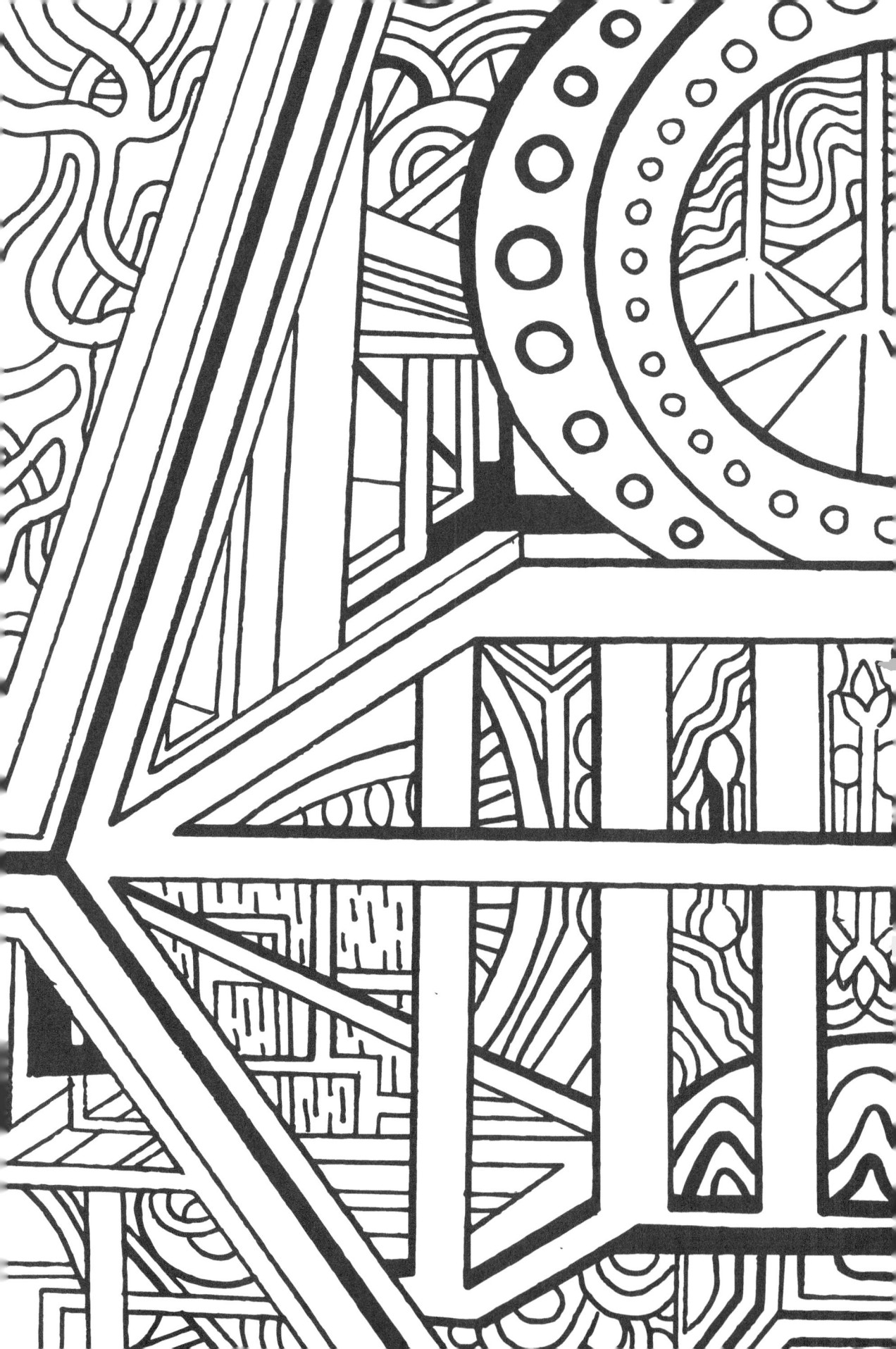

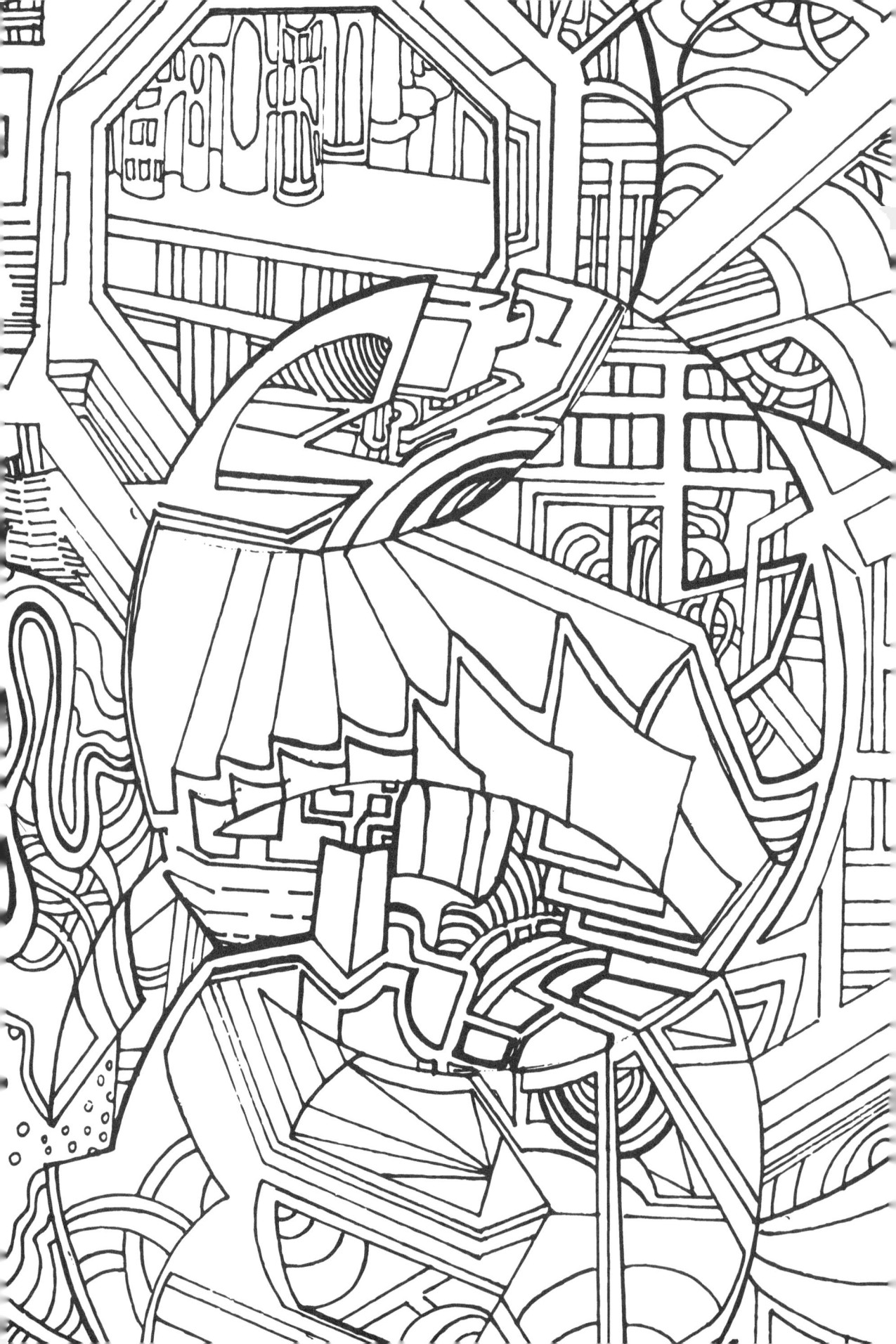

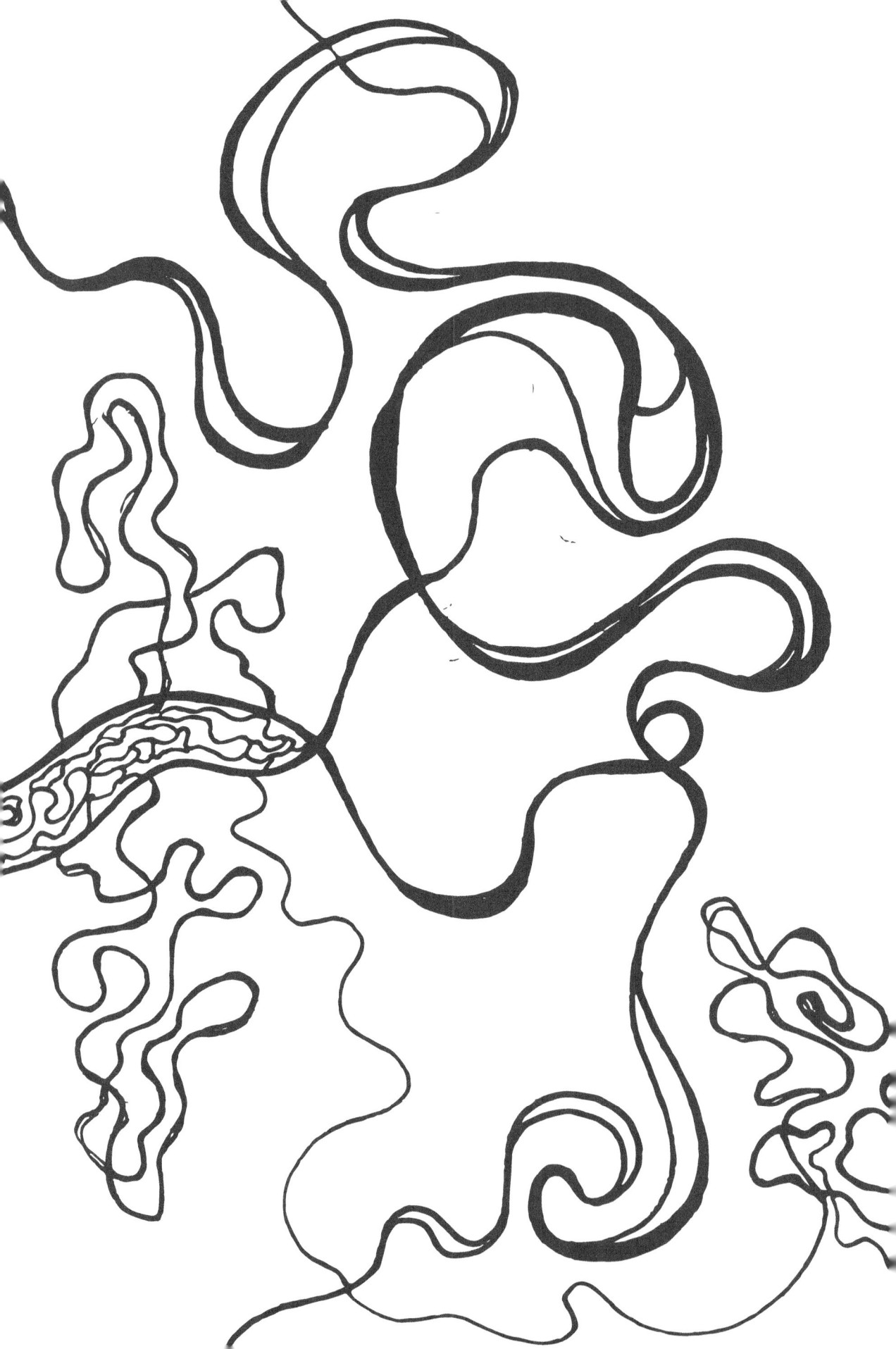

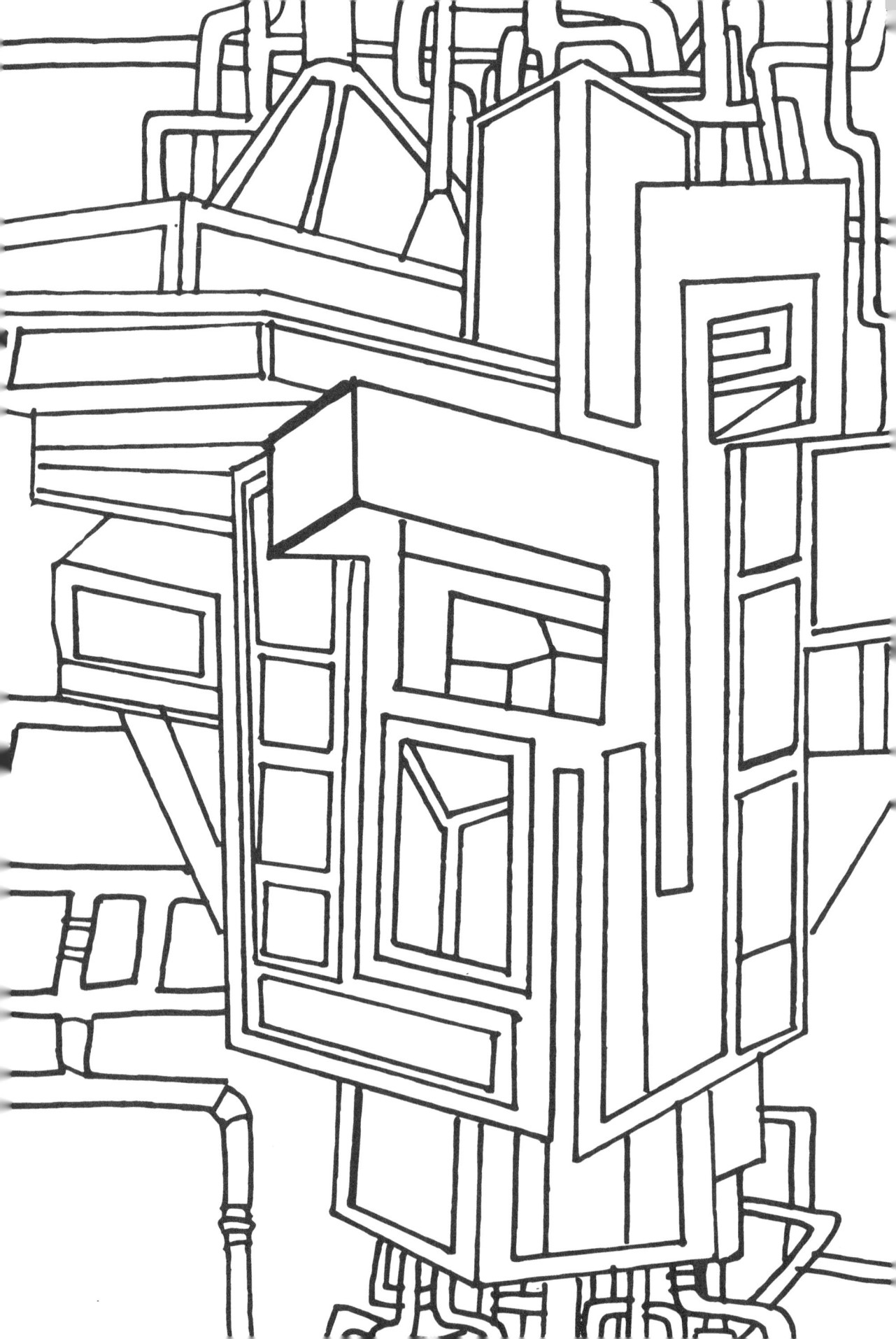

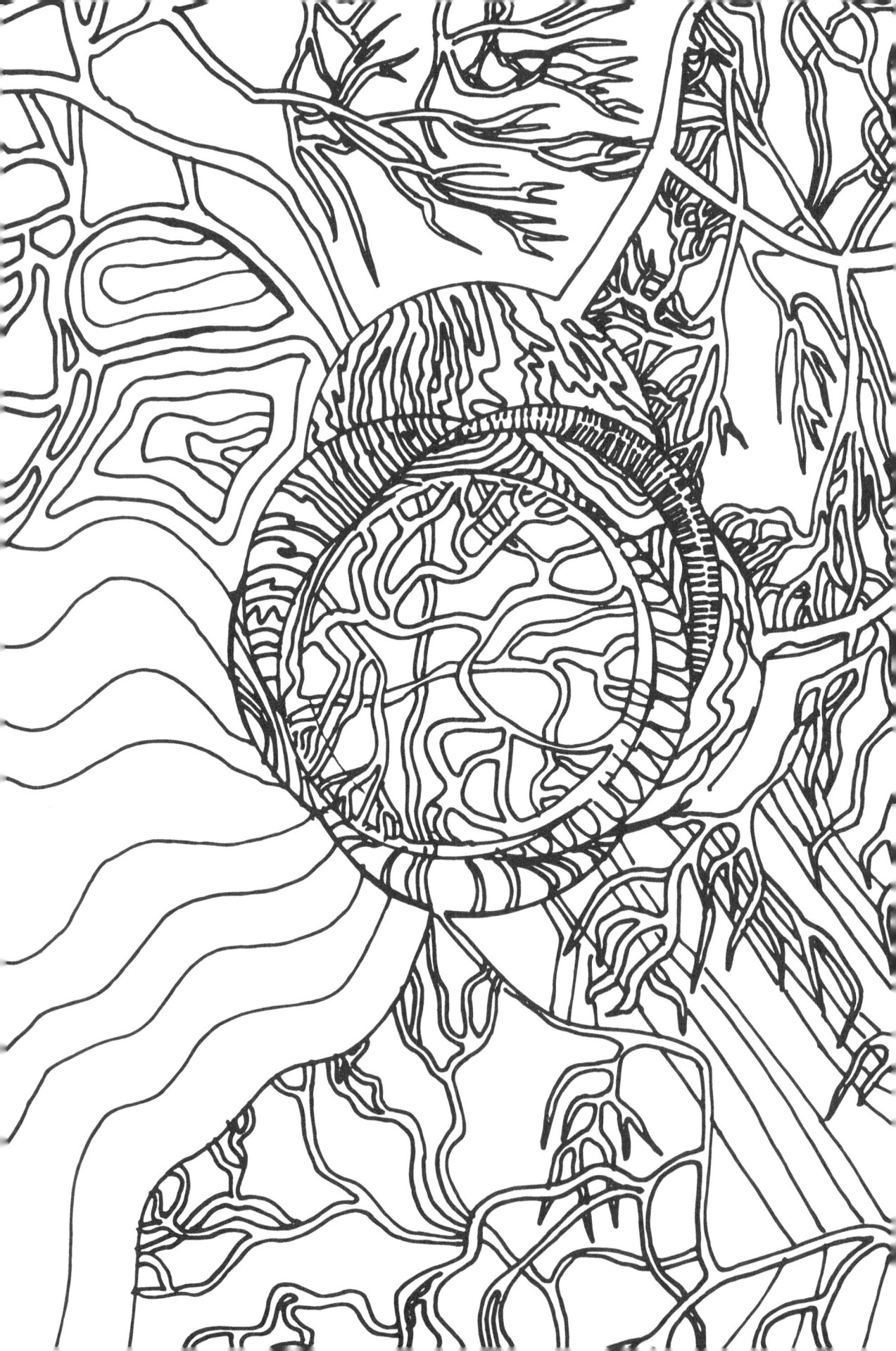

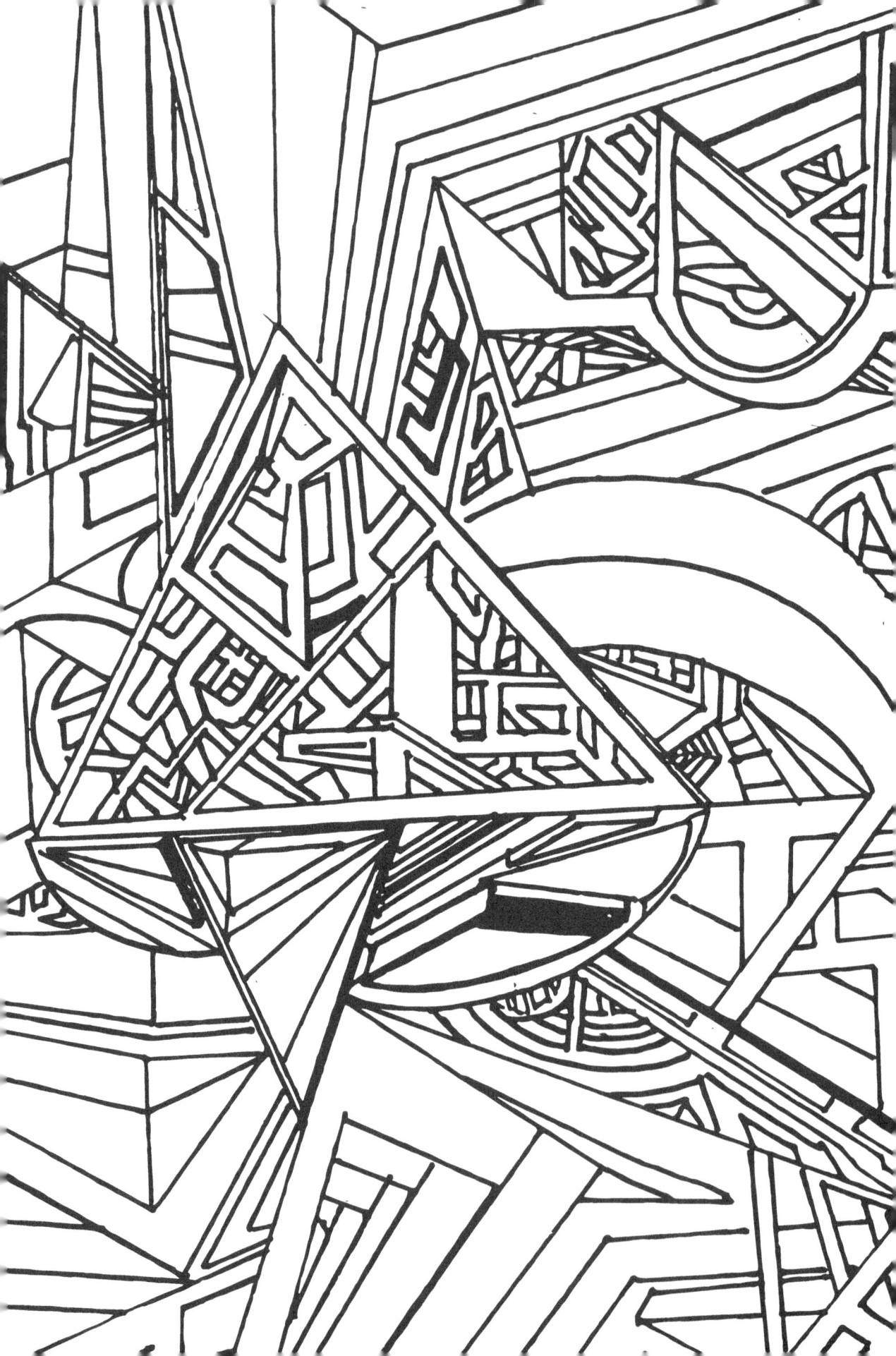

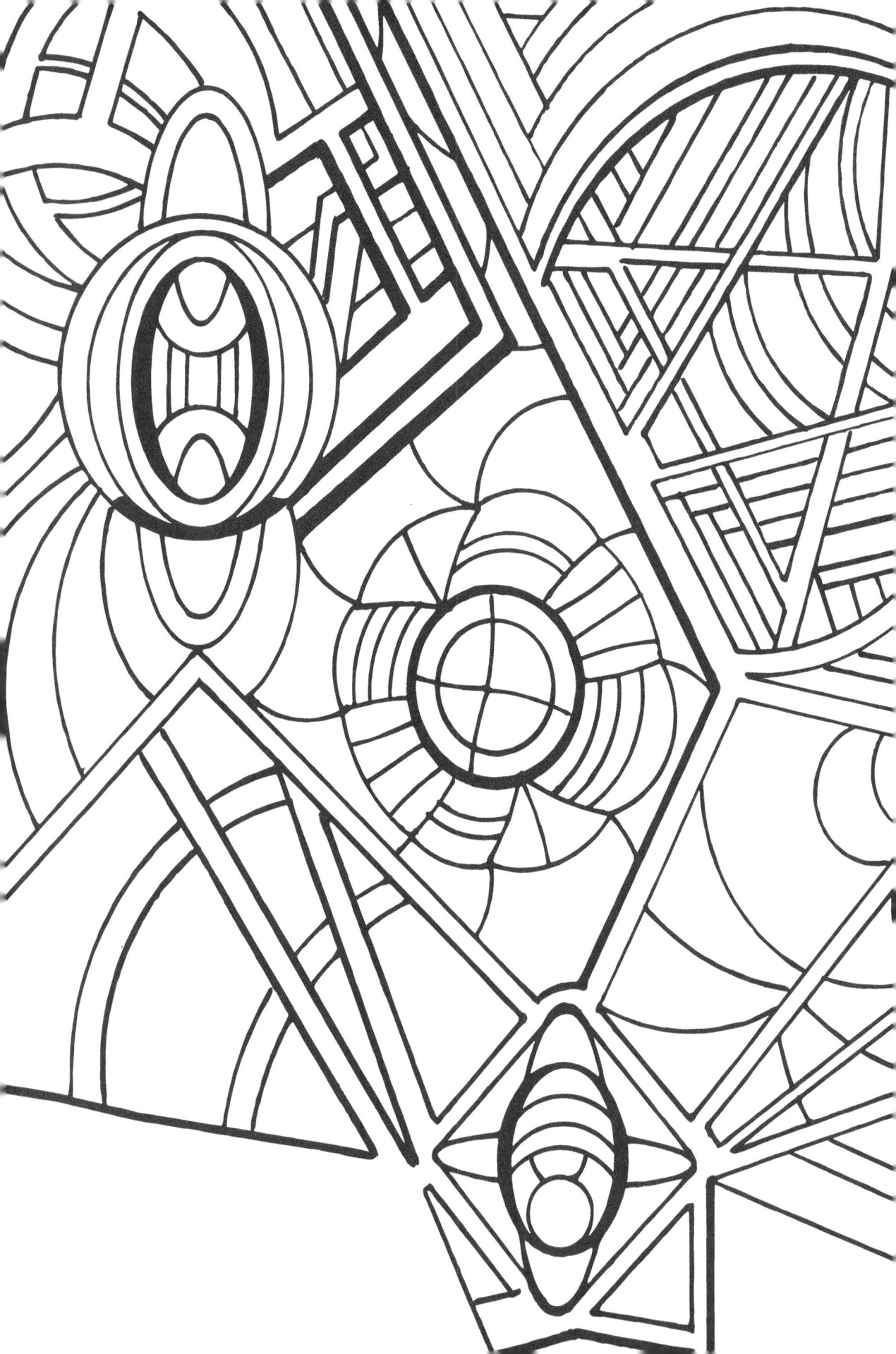

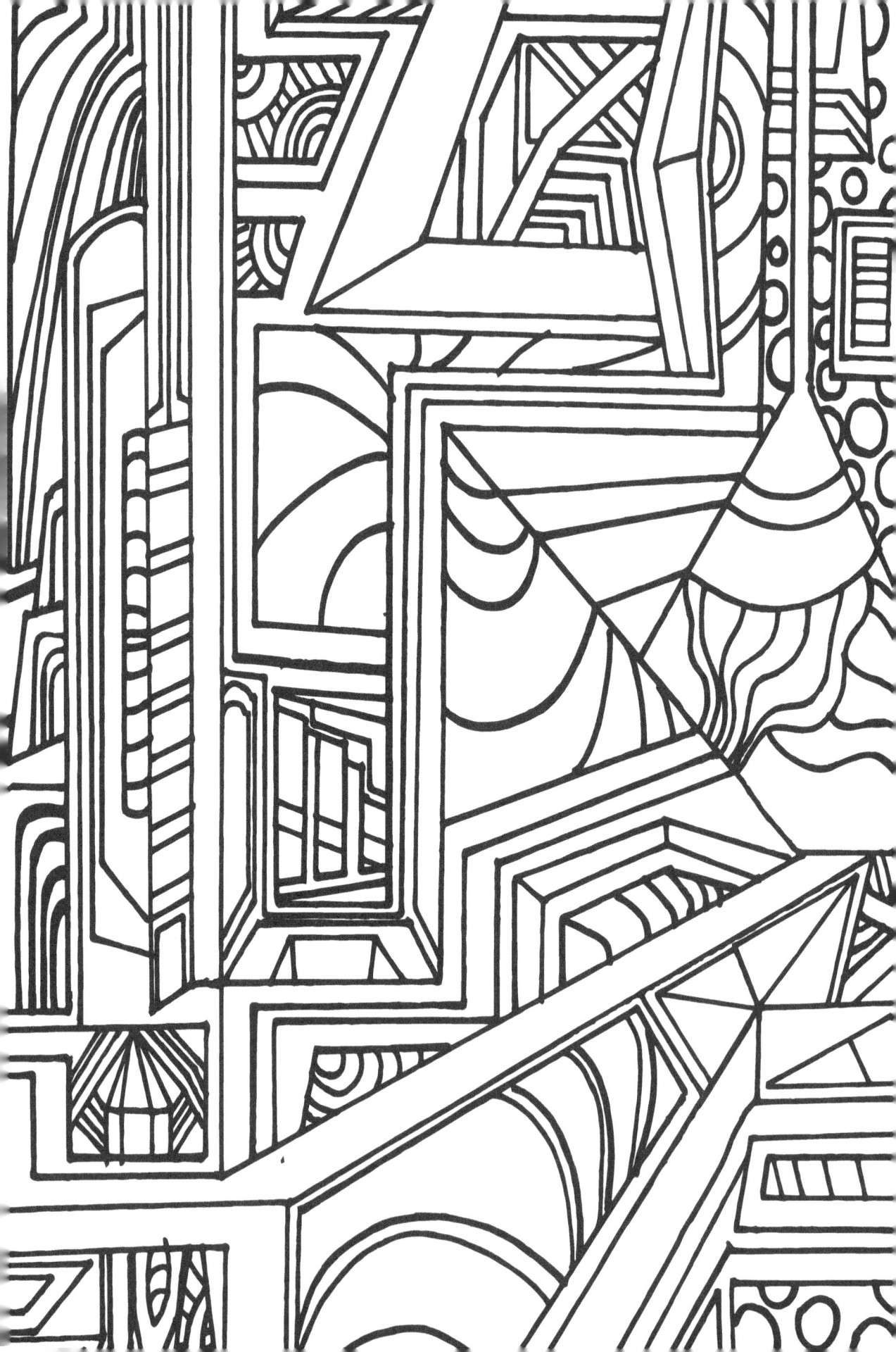

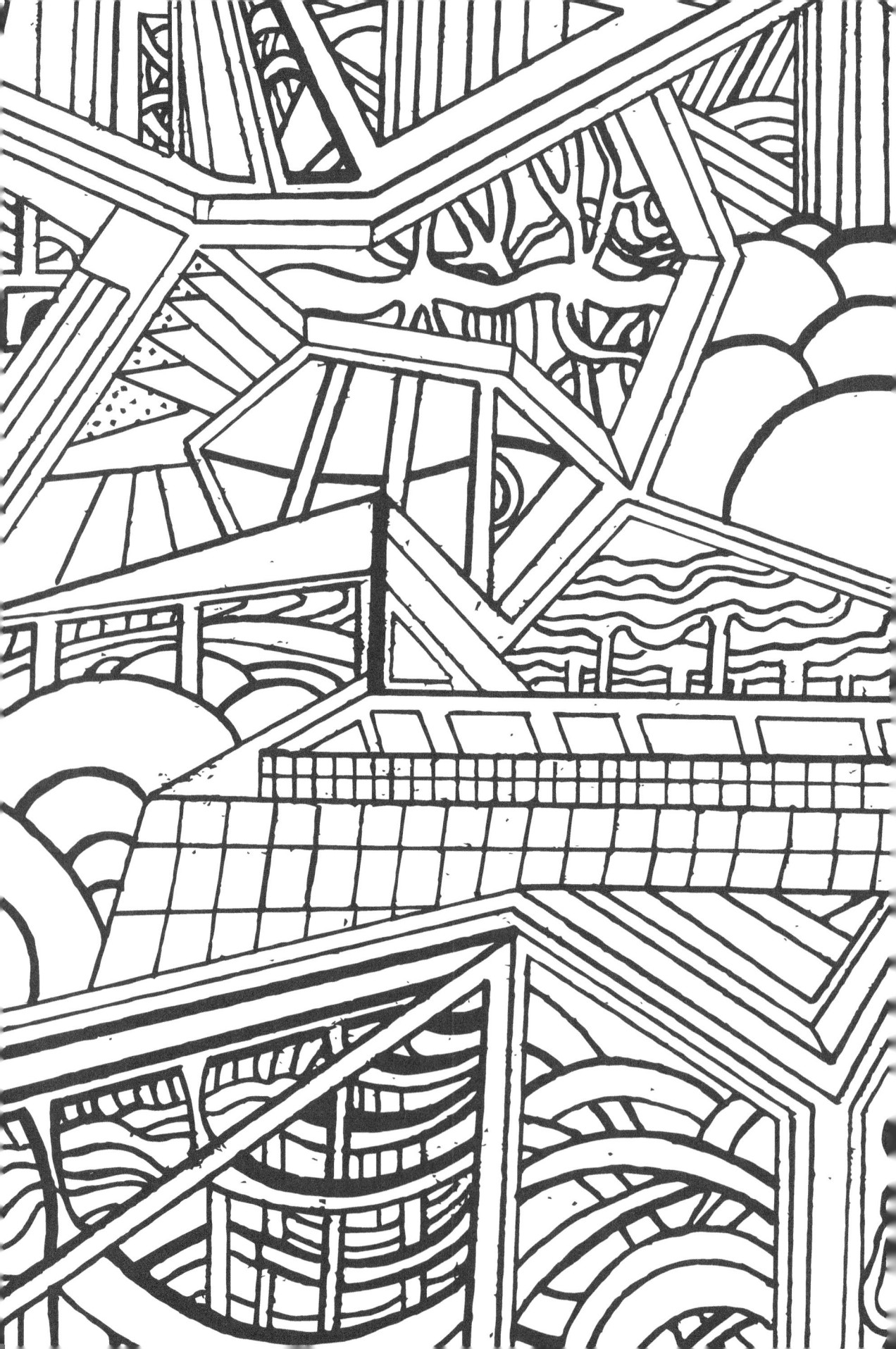

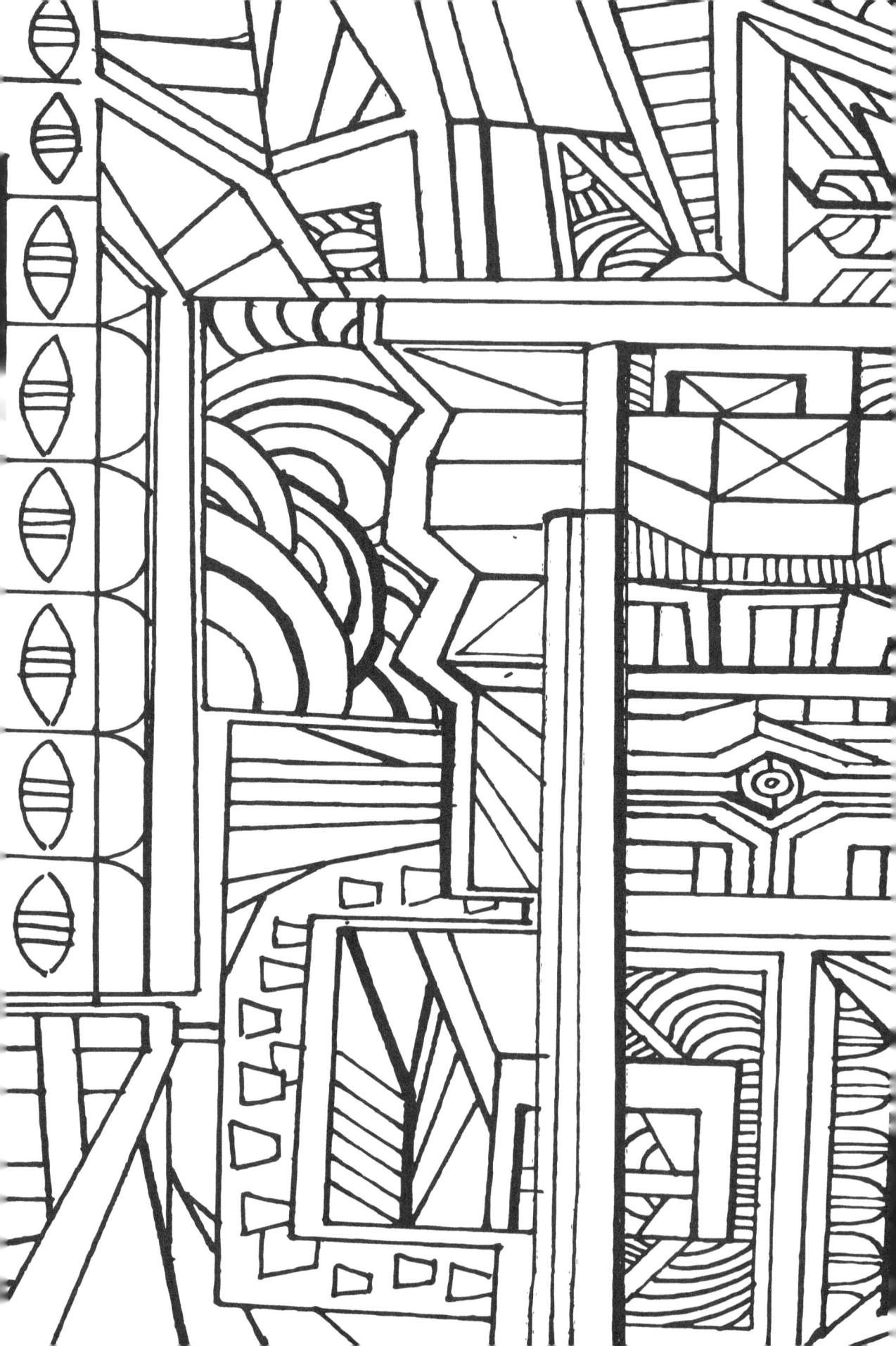

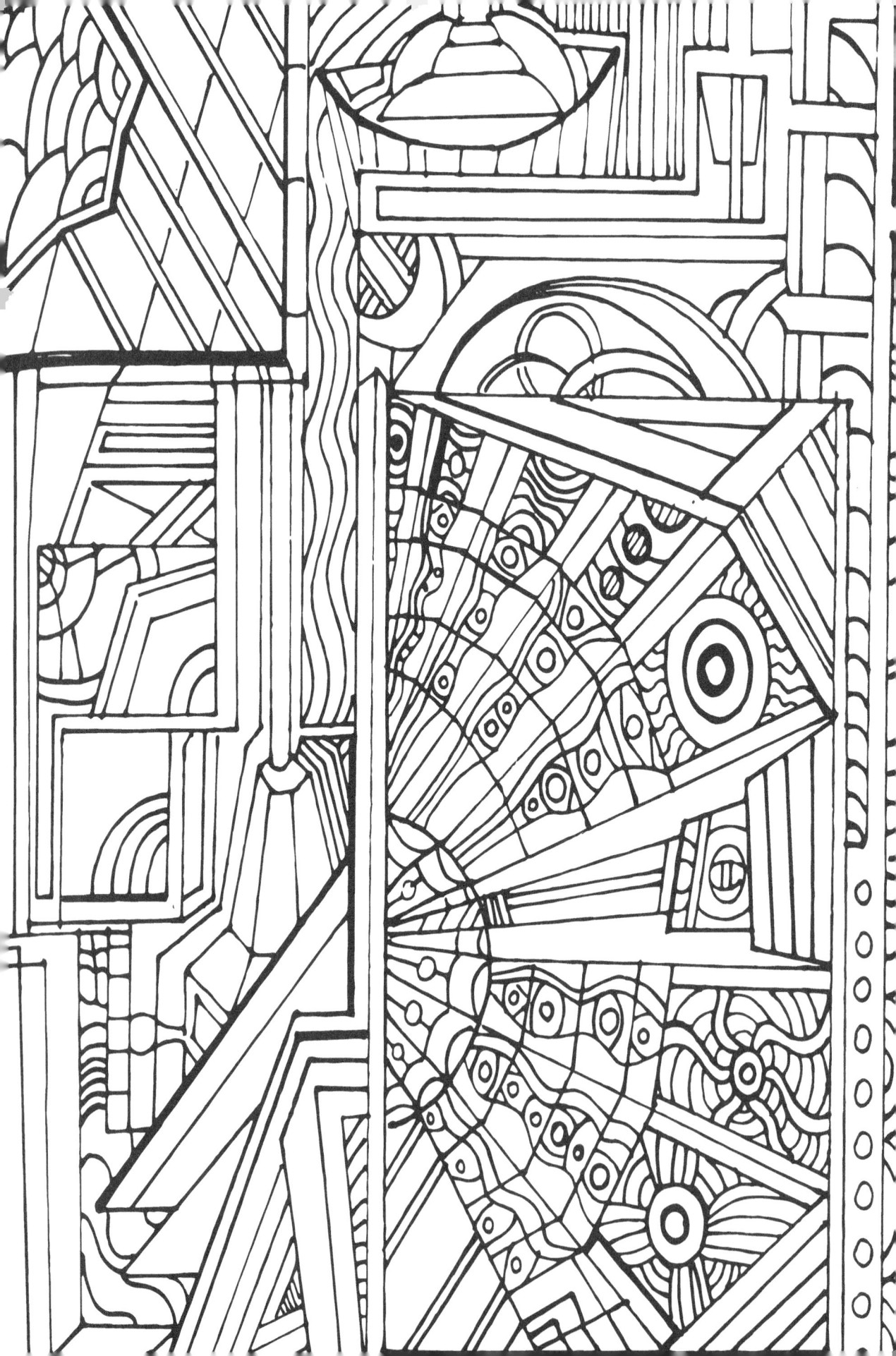

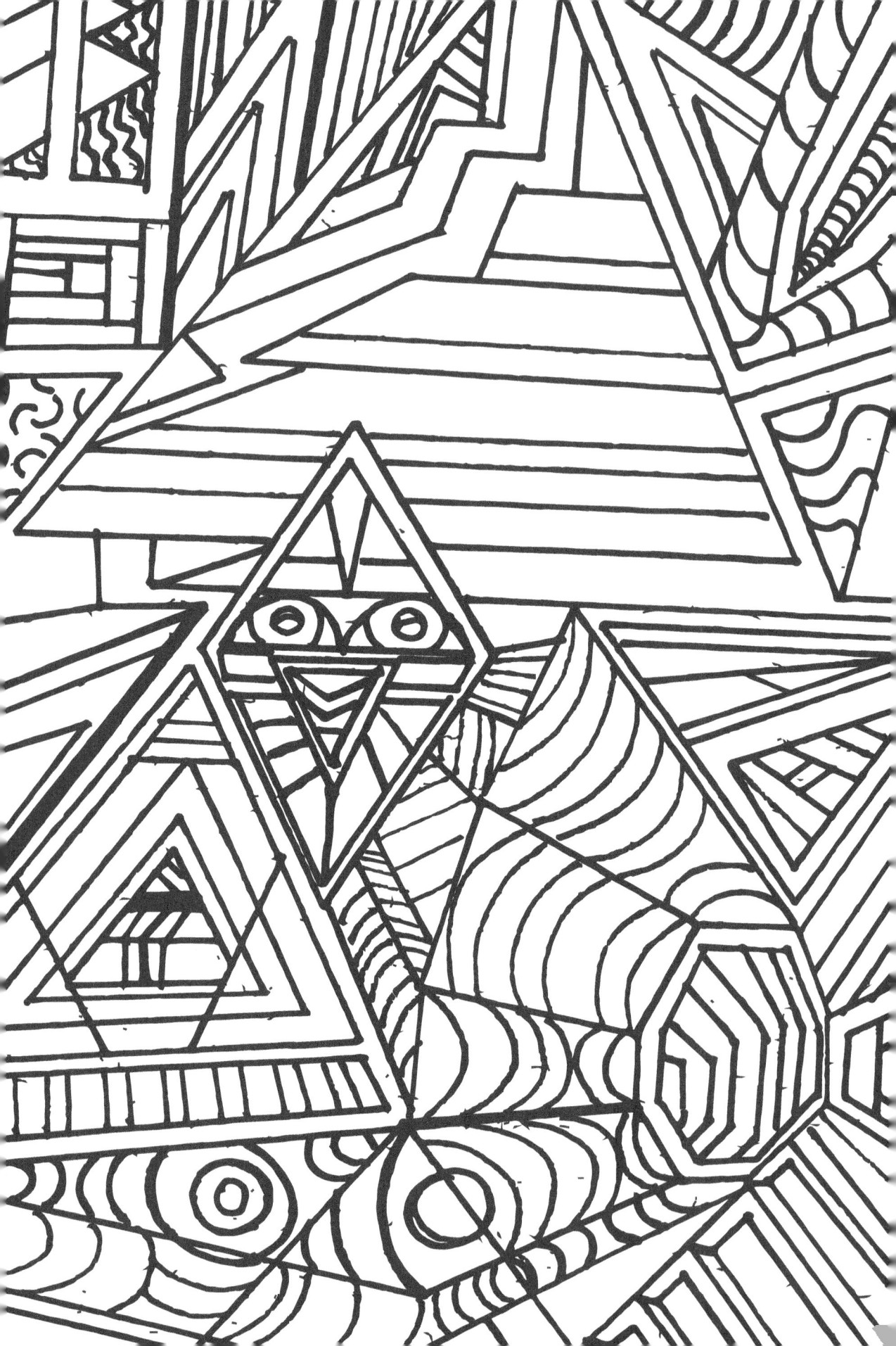

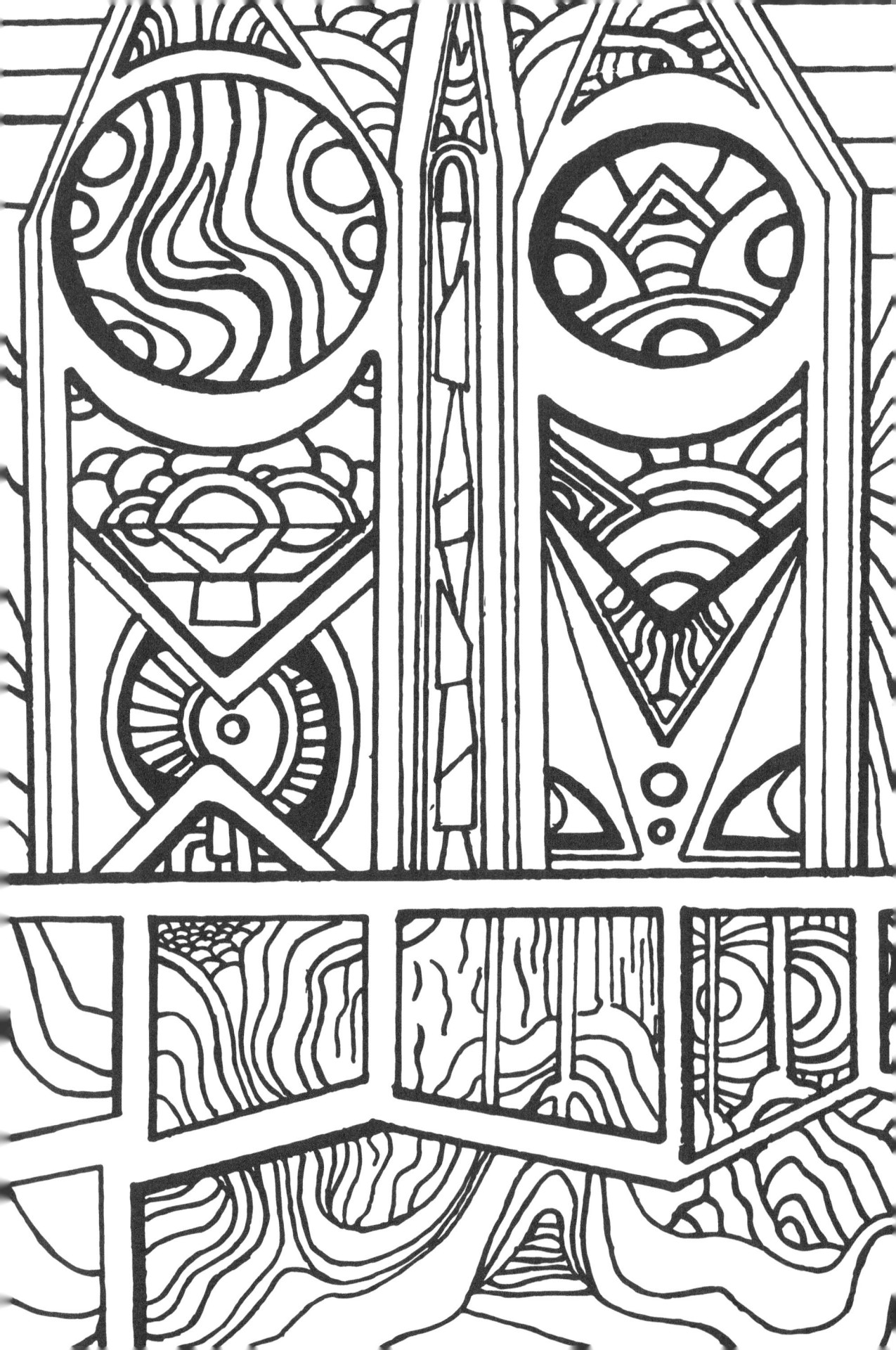

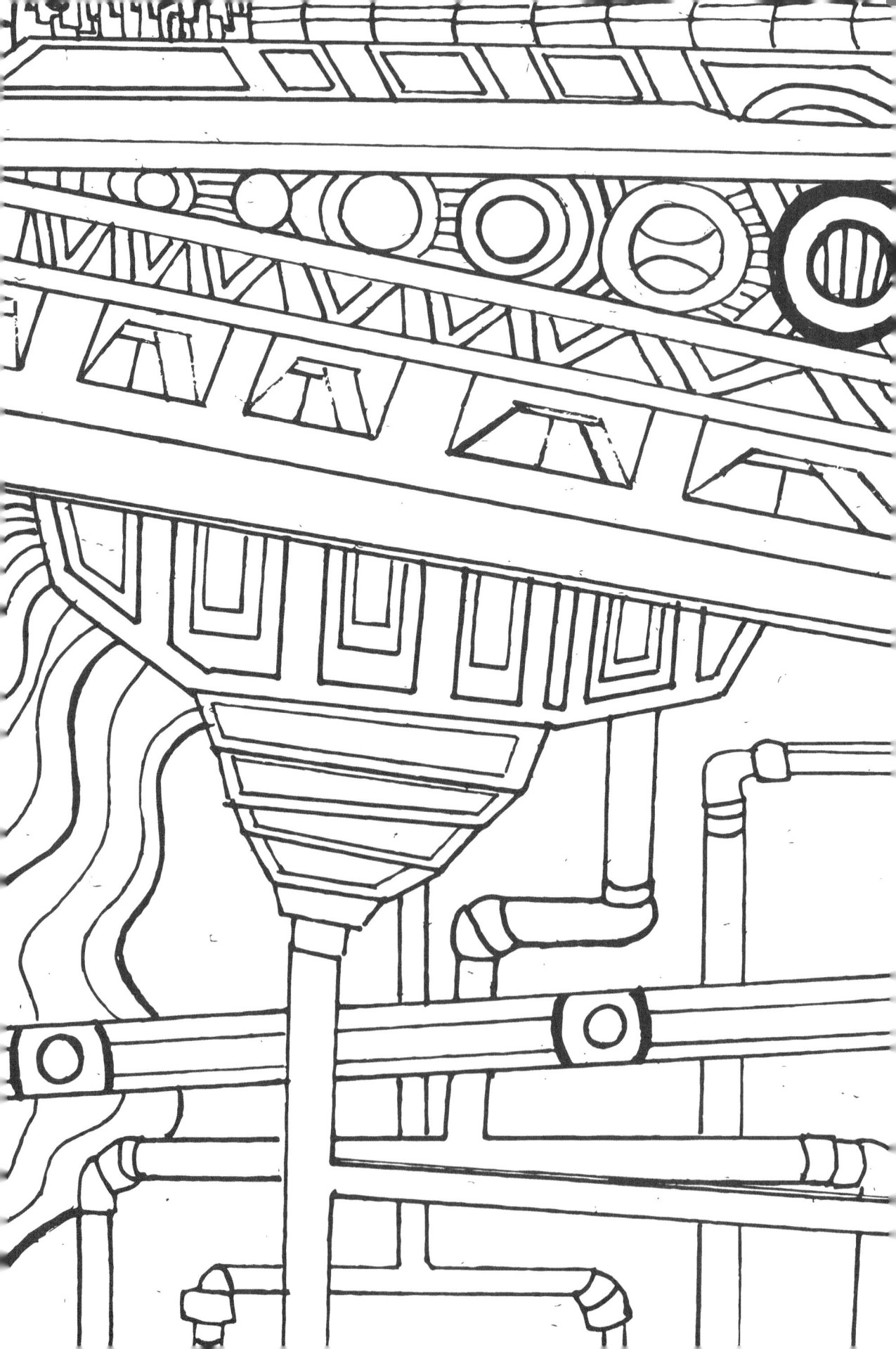